The Secret of the Light

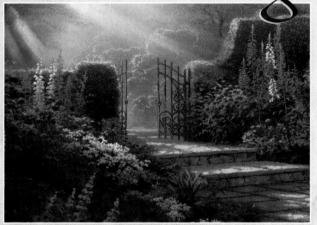

THOMAS KINKADE & DAVID JEREMIAH

COUNTRYMAN

Nashville, Tennessee

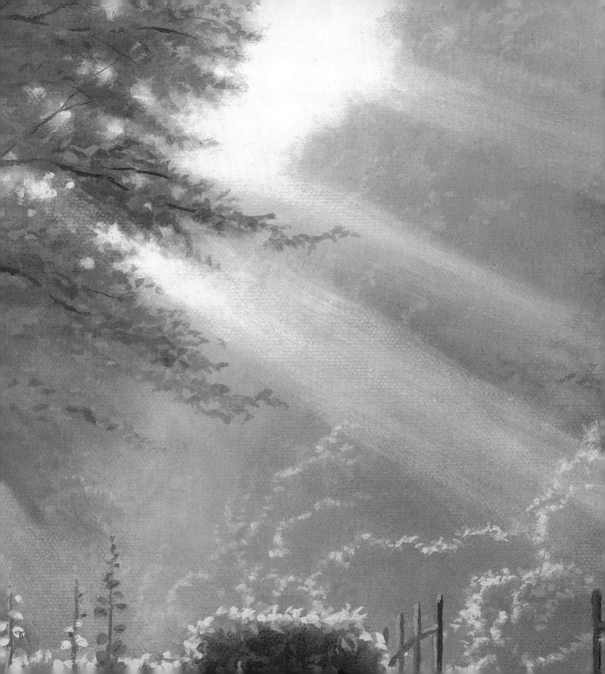

"No one, when he has lit a lamp, puts it in a secret place or under a basket, but on a lampstand, that those who come in may see the light. The lamp of the body is the eye. Therefore, when your eye is good, your whole body also is full of light. But when your eye is bad, your body also is full of darkness. Therefore take heed that the light which is in you is not darkness. If then your whole body is full of light, having no part dark, the whole body will be full of light, as when the bright shining of a lamp gives you light."

LUKE 11:33–36

Table of Contents

Then God said, "Let there be light"; and there was light.

And God saw the light, that it was good; and God divided the light from the darkness. God called the light Day, and the darkness He called Night. So the evening and the morning were the first day.

GENESIS 1:3–5

Of everything in the universe, God made light first. Light is one of the dominant metaphors throughout the Bible for the truth God calls us to know and to live, while its opposite—darkness—frequently describes an unholy nature.

Christians are called to be light, just as Jesus was light. May this book illumine your understanding of what it means to be light in a dark world.

"That they may know from the rising of the sun to its setting That there is none besides Me. I am the LORD, and there is no other; I form the light and create darkness, I make peace and create calamity; I, the LORD, do all these things. Rain down, you heavens, from above, And let the skies pour down righteousness; Let the earth open, let them bring forth salvation, And let righteousness spring up together. I, the LORD, have created it."

ISAIAH 45:6–8

"I am the light of the world. He who follows Me shall not walk in darkness, but have the light of life."

JOHN 8:12

"No one, *when he has lit a lamp,*

puts it in a secret place or under a basket, but on a lampstand, that those who come in may see the light. The lamp of the body is the eye. Therefore, when your eye is good, your whole body also is full of light. But when your eye is bad, your body also is full of darkness. Therefore take heed that the light which is in you is not darkness. If then your whole body is full of light, having no part dark, the whole body will be full of light, as when the bright shining of a lamp gives you light."

LUKE 11:33–36

It is not an accident that the claim of the Lord Jesus Christ to be the light of the world occurs immediately after the story of the woman taken in adultery (John 8). That story is a great revelation of the darkness of man's nature. In the midst of that setting of moral debauchery (not so much on the part of the woman who sinned, but on the part of the Pharisees who trapped her in her sin) shines forth the purity and brightness of Jesus Christ as He shows the contrast between His purity and the awful, ugly darkness of men's hearts.

His choice of words was also no accident. It resonated with every Jew who heard it. At night during the Jewish Feast of Tabernacles, two great lamps were lit in the courts of the temple. These were said to have cast their light over every quarter of the city of Jerusalem. The lamps were meant to recall the great pillar of cloud and fire that had accompanied the people as they marched through the wilderness in the desert. This was the pillar that had

appeared on the day when the people left Egypt. It stood between the Israelites and the pursuing army of the Egyptians the night before the crossing of the Red Sea. It kept the Jewish people from being attacked. Later, it guided the people through the wilderness. It also spread out over them to give shade by day and light and warmth by night. In clear reference to that ceremony of lighting the lamps and to the miraculous pillar itself, Jesus made His claim to be this world's light. "I AM the Light of the Word."

Jesus was saying to them that God is once again among His people. God has come again to shine among His people. God is now again appearing in His glory, and once again, He will fill the Holy of Holies of the hearts of God's people by being the Christ who is the answer to the Messianic prophecies.

"I have come as a light into the world, that whoever believes in Me should not abide in darkness."
JOHN 12:46

THE LIGHT OF EXAMPLE

There is a beginning to Jesus being the light of the world, the moment of His incarnation.

"As long as I am in the world, I am the light of the world." JOHN 9:5

Something is about to change. Jesus is about to leave the world, and this passage of Scripture tells us that, as long as Jesus is in the world, He is the light of the world. This means that when He leaves, He's no longer the light. Jesus Christ, today, is *not* the light of the world.

Jesus said, "You are the light of the world." MATTHEW 5:14

Wait a minute, Lord, I thought You said You were the light of the world?

No, that's as long as I am in the world, but when I am out of the world, you are its light.

Notice the rest of this passage. *"A city that is set on a hill cannot be hidden. Nor do they light a lamp and put it under a basket, but on a lampstand, and it gives light to all who are in the house. Let your light so shine before men, that they may see your good works and glo-rify your Father in heaven"* (Matthew 5:14–16).

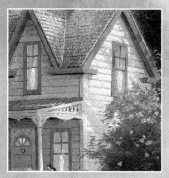

We are to reflect the light of Jesus Christ on this earth in His absence.

We bear an overwhelming responsibility to be God's reflectors. The dark world in which we live cannot see the light of Jesus Christ unless people see that light through us. Jesus does not walk among us as He did during that time. Jesus has passed the mantle of being the light of the world from Himself to us, and He tells us, "You are now what I was when I was here." That's an awesome thought!

On the famous Eddie Stone lighthouse in England are inscribed these words: "To give light and to save life." That's it! That's what God has given us to do, to give light and to save life.

The sword of the Spirit is the Word of God, and the light which we have is the reflection that comes to us by virtue of our relationship with Jesus Christ. He was the light of the world when He walked among us. Now He expects us to reflect Him in our generation, to allow Him to flow through us to the world of darkness that is around us. There will be no Christ seen apart from the Christ that is seen in us.

Jesus lit the lamp—us—and now we need to shine.

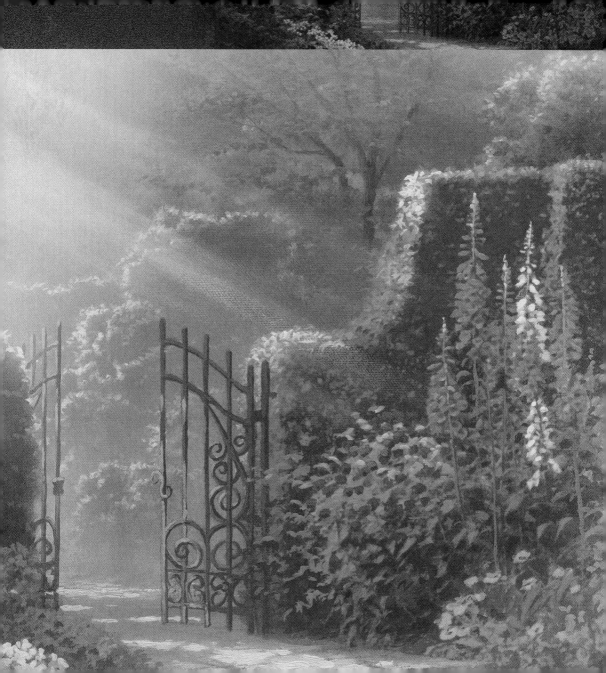

For you were once darkness, but
now you are light in the Lord.
Walk as children of light.

EPHESIANS 5:8

*Living
on a
Lampstand*

Thomas
Kinkade

"No one, when he has lit a lamp, puts it in a secret place or under a basket, but

on a lampstand,

that those who come in may see the light. The lamp of the body is the eye. Therefore, when your eye is good, your whole body also is full of light. But when your eye is bad, your body also is full of darkness. Therefore take heed that the light which is in you is not darkness. If then your whole body is full of light, having no part dark, the whole body will be full of light, as when the bright shining of a lamp gives you light."

LUKE 11:33–36

You know what's great about living today? This is the darkest day we have ever had in American culture. Our culture is more corrupt now than in all of our history. But the wonderful thing about that is that the darker the night, the brighter the light!

In the midst of a dark world, believers are to shine forth as light and offer others the hope of God's Word. The apostle John tells us that Jesus was *"the light of men"* (John 1:4). Jesus said, *"As long as I am in the world, I am the light of the world"* (John 9:5). When the Savior was speaking to His disciples, He said, *"You are the light of the world"* (Matthew 5:14), and in that same context He commanded them to *"Let your light so shine before men, that they may see your good works and glorify your Father in heaven"* (Matthew 5:16).

Do all things without complaining and disputing, that you may become blameless and harmless, children of God without fault in the midst of a crooked and perverse generation, among whom you shine as lights in the world. PHILIPPIANS 2:14-15

The sequence of Paul's directives is intentional; we must be blameless and harmless before we can shine forth as lights. When we shine as lights in the world, the testimony of our personal holiness makes an impact on those around us. And when a godly life is accompanied by the presentation of the Word of Life, the effect can be dramatic.

The Word of Life is the total message of God's Word. It not only brings life to those who are dead in their sins, it also sustains life each day for the disciple who is nurtured by it.

THE LIGHT OF EXAMPLE

Child of light, you are meant to "walk worthy of God who calls you into His own kingdom and glory."

That's the goal, to shine so that others are encouraged to walk in a godly lifestyle. This is not just the responsibility of the preacher; it's the responsibility of all of us. Every one of us has someone in our life who is following after us in the faith. We have been saved a

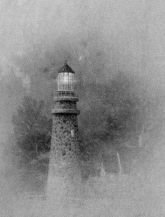

lot longer than they have, and in some way God is using us to mentor them and to encourage them. What is our goal? To help them learn how to walk worthy of God who called them into His kingdom and His glory.

That is the goal: maturity. Not perfection in the sense of absolute perfection, but perfection in the sense of spiritual maturity in that we walk worthy of the Lord.

Our lives are ministries, and that maturing process is what all ministry should be about. What are we trying to do with children when we teach them? We are trying to teach them to grow up in 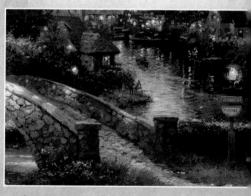 Jesus Christ and learn how to live empowered Christian lives.

As we minister to others, we can examine Paul's assertions and ask ourselves, *"Is this a time for me to be tender as a mother?"* (1 Thessalonians 2:7). *"Or is this the time for me to be strong as a father?"* (1 Thessalonians 2:11). *"Or is this the time when my example and my life should shine through to them so that without my saying anything they can see in me what they should do?"* (1 Thessalonians 2:10).

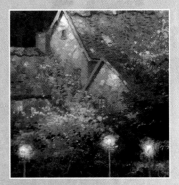

We should never be bashful in saying to young Christians, "If you want to live the Christian life and walk in the right way, I want to encourage you to watch me." That's a scary thing to say, but that is what the New Testament teaches. We are to minister by example, and we are to let people say, "I want to imitate them as they imitate Christ."

The only Christ people see is the Christ walking around in the body of Christ, enshrined in His people.

A WELL–LIT HOME

Have you ever looked out the window of an airplane at night? Sometimes you may see a lake or stream, or a glint of silver in the moonlight. But most of the time it's just a wide

swath of darkness, stretching on for mile after mile. And then on the landscape, one little twinkling light captures your attention. Most likely, it's some lonely farmhouse, and you find yourself wondering about the people dwelling in that little pool of light. Are they up late, reading or watching television? Maybe they are praying to the Lord at that very moment. Do they have any concept that someone forty thousand feet above them has seen their little light, and is thinking about them?

Jesus said His disciples are the light of the world. We're supposed to be like cities on a hill, visible at a great distance, especially in the night. And friends, as the darkness gathers and the light shines brighter and brighter, it's like a magnet in the gloom . . . attracting attention . . . sparking curiosity . . . drawing people toward the comfort and security and beauty it offers.

That's a good picture of the Christian home in today's world. One of God's most important tools for extending His kingdom is the Christian family. He not only wants to use us to bring our children to Christ, but He also wants our families to attract others into a vital relationship with Him.

The Bible says that we are to create such an atmosphere in our homes that at an early age our children will be drawn to know the Lord Jesus Christ. When we win our children to Christ, then they will be ours and His forever.

God is so big that no one is too little to bring the Good News of Jesus Christ to those who don't yet know Him. Through the power of almighty God, our families can become bastions of light and life to our neighbors who sorely need both.

THE LIGHT OF FELLOWSHIP

Every single person can have a part in lighting up the darkness. It's all about togetherness. We can't do it alone. The staff at your church can't do it alone. Your church needs everyone to light a candle and hold it aloft.

There is a verse of Scripture that became real to me when my wife and I were on a moonlit cruise while visiting San Diego many years ago. I had been reading Matthew 5:14 in my Bible that day: *"A city that is set on a hill cannot be hidden."* As we went out into the bay, we

stood for a while on one side of the excursion ship and looked away from the city. Out there, it was dark. Just here and there a few lights. You couldn't even tell for sure where the land began and the water ended as we stood on that side of the ship. Then we walked around to the other side; and from that perspective we could see the beautifully lit landscape of San Diego. It suddenly impressed upon me that this experience was an illustration of the verse I had read. Here on the one side in the landscape were isolated lights. You couldn't be sure what was going on there. But on the other side was the brilliant light that was made up of the configuration of millions of lights that had been brought together. You couldn't miss that! That was a city set on a hill.

When God brings the church together, He gathers all the individual lights from out there on the landscape, and He brings them together in community that we call a city. And through that city, He builds a light so bright no one can miss it.

25

THE LIGHT OF UNITY

Therefore receive one another, just as Christ also received us,

to the glory of God.

ROMANS 15:7

"Receive one another." This is the mandate for unity.

"Just as Christ has received you." This is our model.

"For the glory of God." This is our motivation in

all things.

When believers accept one another as Christ has accepted us, we glorify the name of almighty God.

When God sees members of a church getting along with each other and accepting one another, then this unity of the body of Christ brings glory to almighty God.

But when we allow splitting off into groups and fighting with one another and dissensions among ourselves, we mar the testimony of God in the world where we are supposed to shine as examples and testimonies for Him.

Having predestined us to adoption as sons by Jesus Christ to Himself, according to the good pleasure of His will, to the praise of the glory of His grace, by which He made us accepted in the Beloved.

EPHESIANS 1:5–6

Now to Him who is able to do exceedingly abundantly above all that we ask or think, according to the power that works in us, to Him be glory in the church by Christ Jesus to all generations, forever and ever. Amen.

EPHESIANS 3:20–21

What you do in your church affects the glory of God. How many of you know people who have been in churches that are going through terrible times? Splits, fighting, dissension— you almost hate to go to church because all you hear is discord and division. In contentious situations, is a light shining that will cause others to glorify God? No! When people in the world see believers attacking each other, they mock us. They make fun of us. They criticize us. They say, "Here you are supposed to be in the family of God, but you can't even get along with each other."

God's glory is promoted when we function in the body as we ought to . . . in unity.

Therefore receive one another, just as Christ also received us, to the glory of God. ROMANS 15:7

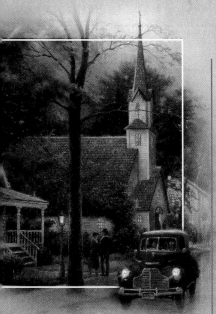

"If My people who are called by My name will humble themselves, and pray and seek My face, and turn from their wicked ways, then I will hear from heaven, and will forgive their sin and heal their land."

2 CHRONICLES 7:14

LIGHT OF THE NATIONS

We must look inward before we can look outward.

Everybody wants to blame the problems in our culture on Hollywood, or the news media, or all of the other groups we put on the list. But the problem in our country is us. We're the Christians. We are supposed to be the salt of the earth and the light of the world. We are supposed to be the difference makers; and if we are not right, the world in which we live cannot be right.

We'll never transform the world into a utopian place ourselves—that's something God plans to do Himself—but if we live for Christ, if we honor God, if we look inward before we look outward, we can make a difference.

Revival does not start in the culture, but in the church. Revival does not come in the heat of the controversy, but in

the heart of the Christian. So while we are railing on all of the problems in our world today, let's be careful that we look inward before we look outward.

Check the batteries in your light before you complain about the dark.

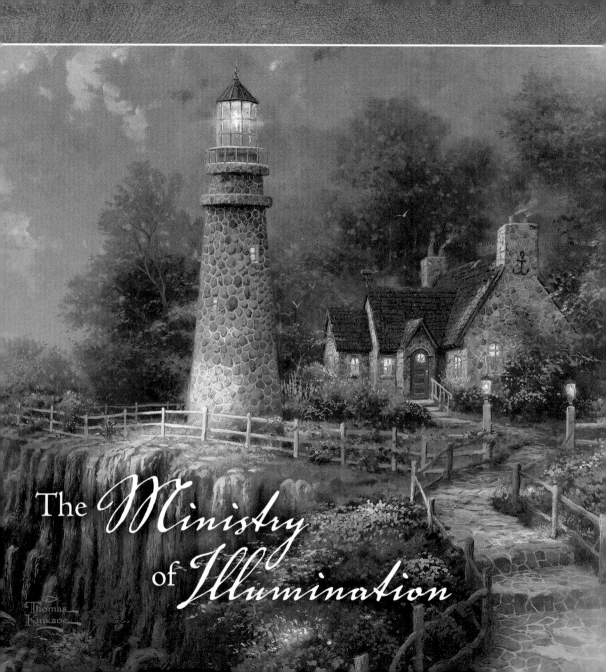

The *Ministry*
of *Illumination*

Thomas
Kinkade

"No one, when he has lit a lamp,

puts it in a secret place or under a basket, but on a lampstand,

that those who come in may see the light.

The lamp of the body is the eye. Therefore, when your eye is good, your whole body also is full of light. But when your eye is bad, your body also is full of darkness. Therefore take heed that the light which is in you is not darkness. If then your whole body is full of light, having no part dark, the whole body will be full of light, as when the bright shining of a lamp gives you light."

LUKE 11:33–36

The major message the world tells Christians today is, "You want to have your faith? Go for it! But keep it to yourself."

But Jesus, in no uncertain terms, has told us that we cannot be Christians totally in private.

The Christian life is to be lived out in the public where it is seen and where it is felt.

"Let your light so shine before men, that they may see
your good works and glorify your Father in heaven."

MATTHEW 5:16

One of the great "salt and light" Christians of the eighteenth century was John Wesley. He traveled over 250,000 miles on horseback throughout England, Scotland, and Wales preaching an estimated 40,000 sermons. When he commented on Matthew 5:16, Wesley

said, "I will endeavor to show that Christianity is essentially a social religion, and that to return it to a solitary religion is indeed to destroy it."

We are living in a day when the pressure of the world is to return Christianity to a solitary religion. This movement is gaining momentum in our culture, and it is going in a direction where it will become almost impossible for us as God's people to open our mouths about our faith if we are not careful.

THE NATURE OF LIGHT

Light must be prominent—We are to be conspicuous in our witness to the world by putting our light up on a candlestick where everybody can see it. Let your light shine. Just be who you are. Don't put your light under a bushel. When people ask you a reason for your faith, tell them who you are. You are a member of God's forever family. You are living at the highest level you can live on planet earth.

Light has purpose—The purpose of Christians as lights is so that when we shine brightly, through our light, people see Jesus Christ.

Light has a price—There is a cost in being light. A candle cannot be lit without consuming

itself. If you are going to be a light in the world, it will consume you.

Light is praiseworthy—In the Old Testament is the story of Daniel. He was a salt and light follower of God, in spite of his forced servitude to Nebuchadnezzar, a proud, wicked king. One day Nebuchadnezzar was looking over his city and saying, "Look what I did!" And God had had it with him. Nebuchadnezzar was reduced to a beast–man (Daniel 4:33). He ended up eating grass. The Bible says several times that whoever exalts himself, God will humble. Nebuchadnezzar certainly was humbled; in the last part of the fourth chapter of Daniel, you'll read one of the greatest testimonies to the greatness of God. This is from a pagan who gave glory to God because he had seen the good works in the life of Daniel. That's the kind of light God has called us to be—the kind that causes others to glorify God.

WALKING IN THE LIGHT

In his autobiography, Benjamin Franklin tells of a challenge that he had in trying to get the people of Philadelphia to light the outside of their houses. Residents were having problems with crime and people stumbling in dark streets, so he encouraged each person to light the area outside of their house. But Franklin was getting nowhere. No one was doing anything, and he was very frustrated.

And then one day, he got an idea. Franklin put a kerosene light on a pole out in front of his house. That night only his house in the city was lit, and it cast a warm glow all around there. When people walked by, they felt safe and no one was falling.

The next night, another family lit the outside of their house, and after that another one, and pretty soon, without having said a word, everyone in the city began to light their houses at night. What Benjamin Franklin tried to do by admonition was impossible, but what he did by example changed the city.

For you were once darkness, but now you are light in the Lord. Walk as children of light (for the fruit of the Spirit is in all goodness, righteousness, and truth), finding out what is acceptable to the Lord. And

have no fellowship with the unfruitful works of darkness, but rather expose them. For it is shameful even to speak of those things which are done by them in secret. But all things that are exposed are made manifest by the light, for whatever makes manifest is light. Therefore He says:

"Awake, you who sleep,

Arise from the dead,

And Christ will give you light."

EPHESIANS 5:8–14

One of the ways we imitate God is by walking in light. When we become Christians, one of the metaphors that is used to describe the difference in our life is that we now become children of the light. Before, we were darkness itself.

What does it mean when it says we were once darkness? That is a description of who we are before we come to Christ. When we imitate God, and when we walk in the light, when we begin to live as Christians, we change dramatically from what we once were to what we have now become.

And you He made alive, who were dead in trespasses and sins, in which you once walked according to the course of this world, according to the prince of the power of the air, the spirit who now works in the sons of disobedience, among whom also we all once conducted ourselves in the lusts of our flesh, fulfilling the desires of the flesh and of the mind, and were by nature children of wrath, just as the others. EPHESIANS 2:1–3

Darkness is a person: "For we do not wrestle against flesh and blood, but against principalities, against powers, against the rulers of the darkness of this age, against spiritual hosts of wickedness in the heavenly places" (Ephesians 6:12).

Darkness is also a power: "He has delivered us from the power of darkness and conveyed us into the kingdom of the Son of His love" (Colossians 1:13).

Darkness is a preference: "And this is the condemnation, that the light has come into the world, and men loved darkness rather than light, because their deeds were evil. For everyone practicing evil hates the light and does not come to the light, lest his deeds should be exposed. But he who does the truth comes to the light, that his deeds may be clearly seen, that they have been done in God" (John 3:19–21).

Darkness is also a place: "But the sons of the kingdom will be cast out into outer darkness. There will be weeping and gnashing of teeth" (Matthew 8:12).

Our past was darkness, but the light is our future and our present.

But you are a chosen generation, a royal priesthood, a holy nation, His own special people, that you may proclaim the praises of Him who called you out of darkness into His marvelous light. 1 PETER 2:9

We have been called out of the darkness into the light. Now we are light in the Lord.

What Paul is telling us is that we are different. Don't try to blend the light and the darkness to make sort of a grayness. It doesn't work. It's either light or it's dark. But the theology of today, the theology of toleration, the theology that says you can be a Christian and not be different—that's what our culture wants, not what our God wants. Go back and read what the Scripture says. We have been called out of that darkness, and we are now in the light.

So how do we walk as children of light? With goodness, righteousness, and truth (Ephesians 5:9).

We have *goodness* in our relationships with others. We have been translated out of the darkness of deceitful and destructive relationships. The fruit of the Spirit—which also could be called the fruit of the light—is in us. *"See that no one renders evil for evil to anyone, but always pursue what is good both for yourselves and for all"* (1 Thessalonians 5:15). A person may come

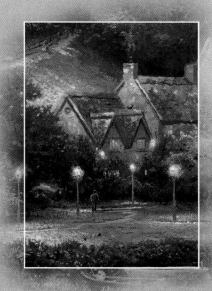

out of the darkness into the light, but he is not walking according to the light unless his relationship with others is goodness.

We have *righteousness* in our relationship with God. This has to do with honesty, openness, and doing good things. "*O man of God . . . pursue righteousness, godliness, faith, love, patience, gentleness*" (1 Timothy 6:11).

We have *truth* in our relationship with ourselves. We are men and women of integrity, our word is our bond, and our persona outwardly is who we are inwardly.

When you belong to the kingdom of light, you have a new *desire*—"*Finding out what is acceptable to the Lord*" (Ephesians 5:10). You want to do whatever you can that pleases the Lord. You want to get on your knees in the morning and say, "Lord Jesus, help me to take You with me wherever I go. Help me to bring the presence of Jesus into every situation."

You see, it's not enough just to call yourself a Christian. If you are going to walk as a Christian, you must desire to please the Lord.

People of the light are *different*. We are to *"have no fellowship with the unfruitful works of darkness"* (Ephesians 5:11). When the old temptations beckon, we must reply, "I cannot fellowship with the unfruitful works of darkness." It is impossible for a Christian to be a Christian and not be *in* the world, but we can be a Christian and not be *of* the world. You see, when Christ comes and lights up our lives, He begins to dispel the darkness, and we can't embrace the darkness while we are walking in the light.

People of the light also have a *new duty*. We are to expose the darkness for the horror it is because *"all things that are exposed are made manifest by the light"* (Ephesians 5:13). When we live as we should, our light becomes a condemnation to the darkness around us. Have you ever noticed that? People are uncomfortable with who we are.

The Bible says this: We are to let our light so shine that men will see our good works and glorify our Father in heaven. If you are who God has called you to be as a believer, you will be a catalyst in any situation; and you can be light in darkness.

THE LIGHT OF HIS COMING

Loving Jesus Christ at Christmastime is a blessed adventure. Don't let it elude you.

All around us are reminders of His birth and of His loving death on our behalf. The manger reminds us that He cared enough to come to be one of us. The tree is a subtle reminder of where He ended up because of His love for us. The darkness of the winter season tells us what we are like before He enters our life. And the brilliant lights remind us that Jesus Christ was the Light of the World, who came to light up our lives, too.

Christmas is a night season. We always go caroling at night. We have our services on Christmas Eve. And isn't it interesting that the Scripture says that the shepherds were *"keeping watch over their flocks by night"* (Luke 2:8)?

Night is a symbol of the darkness of the world's situation. Sorrow and sin and ignorance reigned when Christ came. Judaism had failed. Heathenism was in full bloom. And Paul wrote that *"when the fullness of the time had come, God sent forth His Son"* (Galatians 4:4). Jesus came at just the right moment. In the darkest hour as far as history is concerned, the Light came.

It is the same today, is it not? Men's hearts are dark; they still love darkness rather than light because their deeds are evil. But even those who do not have faith in Christ give testimony to the light of the world by the way they celebrate the holiday hours. Somehow people seem to sense, even in their unbelief, that in this night season there is a message of comfort and reassurance in the person of Jesus Christ.

As you re-read the accounts of the Nativity, notice again that when the angel spoke to Zacharias, he said, *"Do not be afraid."* And when he spoke to Mary, he said, *"Do not be afraid."* And when he spoke to Joseph, he said, *"Do not be afraid."* And when the angels sang to the shepherds, their message was, *"Do not be afraid."*

That is the message we have for the people in the world all around us, watching us—the light—while living in the darkness. It is literally true to say that "the hopes and fears of all the years are met in Thee tonight," in Jesus Christ.

Christmas means we don't have to be afraid of the dark anymore.

D. L. Moody's musician, who led music in the same fashion that Cliff Barrows does for Billy Graham, was a man by the name of Ira Sankey. On Christmas Eve in 1875, Ira Sankey was traveling by steamboat up the Delaware River, and the passengers asked him to sing. It had been his intention to sing a Christmas song, but instead he was prompted to sing "Savior, Like a Shepherd Lead Us," which was one of his favorite hymns.

After the song ended, a man with a rough, weather–beaten face came up to Sankey and asked, "Did you ever serve in the Union Army?"

"Well, yes," Sankey said.

"Can you remember if you were doing picket duty on a bright moonlit night in 1862?"

"Yes," answered Sankey, very much surprised, "but how did you know?"

He said: "Well, I was on duty that night, too. But I was serving in the Confederate Army. And when I saw you standing at your post, I said to myself, 'That fellow will never get away from here alive.' And I raised my musket and took aim. I was standing in the shadow, completely concealed, while the full light of the moon was falling on you. And at that instant, just as you did a moment ago, you raised your eyes to heaven and you began to sing. Music,

especially song, has always had a wonderful power over me, so I took my finger off the trigger. I said to myself, 'Let him sing the song until the end, and then I will shoot him. He's my victim at all events, and my bullet cannot miss him.' But the song you sang then was the song you sang just now, and I heard the words perfectly: 'We are Thine, do Thou befriend us, be the Guardian of our way. Savior, like a Shepherd, lead us.'"

Sankey said, "What happened?"

He said: "When you finished your song it was impossible for me to take aim at you again. I thought, 'The Lord who is able to save that man from certain death must certainly be great and mighty,' and my arm just fell limp at my side. Since that time I have wandered about far and wide. But when I just saw you there standing again, praying as on that other occasion, I knew it was you, and my heart was wounded by your song. Now I want to ask you if you will help me find a cure for my soul."

Sankey was deeply moved and threw his arms around the man who in the days of the war had been his enemy. And that night the stranger came out of the spiritual shadows and into the light of God's love.

The statutes of the LORD are right,
rejoicing the heart. The commandment
of the Lord is pure, enlightening the eyes.

PSALM 19:8

The *Word* of *God*
Enlightens Us

"No one, when he has lit a lamp, puts it in a secret place or under a basket, but on a lampstand, that those who come in may see the light.

The lamp of the body is the eye.

Therefore, when your eye is good, your whole body also is full of light. But when your eye is bad, your body also is full of darkness. Therefore take heed that the light which is in you is not darkness. If then your whole body is full of light, having no part dark, the whole body will be full of light, as when the bright shining of a lamp gives you light."

LUKE 11:33–36

Light takes the darkness away.

What that means in practical terms is that sometimes you are trying to work through a problem for which there doesn't seem to be any kind of answer, but then you begin reading the Bible and all of a sudden it is like God took a huge spotlight and shined it right down on that dark space in your life. God uses His Word to help us see the truth about something that previously we couldn't understand. It enlightens us.

Your testimonies are wonderful; Therefore my soul keeps them. The entrance of Your words gives light; It gives understanding to the simple. PSALM 119:129–130

We only have one irreplaceable text book, and that's the Word of God. When we study

God's Word, carefully analyze and apply its truth, we end up with power in our lives.

When we will not provide a place for the direction of the indwelling Christ, all that is left is the frenzied agenda of our frazzled discipleship. You see, the faster we go, the less time we have to commune with the One we claim to love. The more we focus our attention on the outwardness of our faith, the less vibrancy and reality we have in our walk with God. The Christian life is not built from the outside in; it's built from the inside out.

Your word is a lamp to my feet And a light to my path. PSALM 119:105

For the commandment is a lamp, And the law a light; Reproofs of instruction are the way of life.
PROVERBS 6:23

THE ILLUMINATION OF THE SPIRIT

Even if our gospel is veiled, it is veiled to those who are perishing, whose minds the god of this age has blinded, who do not believe, lest the light of the gospel of the glory of Christ, who is the image of God, should shine on them. For we do not preach ourselves, but Christ Jesus the Lord, and ourselves your bondservants for Jesus' sake. For it is the God who commanded light to shine out of darkness, who has shone in our hearts to give the light of the knowledge of the glory of God in the face of Jesus Christ.

2 CORINTHIANS 4:3–6

Without the Spirit of God shining on our hearts, we can never understand the Bible. The Word of God is incomprehensible to a person who doesn't know the Lord. You can read it. You can memorize it. You can study it all you want. But it will never come alive. The light will never go on because you don't have the right spiritual equipment.

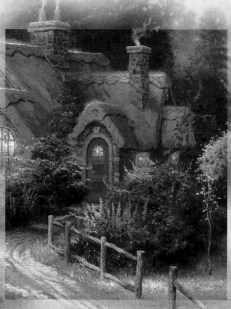

"Even if our gospel is veiled, it is veiled to those who are perishing." This is a description of those who don't know the Lord. *"Whose minds the god of this age has blinded, who do not believe lest the light of the gospel of the glory of Christ who is the image of God should shine on them."*

The Bible says that before you invite Christ into your life, it's like you have scales on your eyes spiritually; you can't really understand the Bible. You can read it for all you're worth, but it doesn't make any sense.

We are told that *"the natural man,"* the man who doesn't know the Lord, *"does not receive the*

things of the Spirit of God, for they are foolishness to him; nor can he know them because they are spiritually discerned" (1 Corinthians 2:14). When the Spirit of God comes to live within us, He opens the Word of God so we can begin to understand it. That's called illumination. It's the Spirit of God shining on the Word, and shining in our hearts, so that the Word begins to make sense.

THE LIGHT OF PROPHECY

We have the prophetic word confirmed, which you do well to heed as a light that shines in a dark place, until the day dawns and the morning star rises in your hearts, knowing this first, that no prophecy of Scripture is of any private interpretation, for prophecy never came by the will of man, but holy men of God spoke as they were moved by the Holy Spirit.

2 PETER 1:19–21

The word "prophecy" comes from two Greek words. One is the word *pro* which means "forth," and the other word is the word *phemi* which means "to speak." So "prophecy" literally means "to speak forth."

A prophet today is someone who speaks forth the Word of God. He is, in essence, an expositor of the Word of God. He opens the Word of God and brings the Word of God out into the light.

Here is what Peter said about the the word of prophecy: *"and so we have the prophetic word confirmed, which you do well to heed as a light that shines in a dark place until the day dawns and the morning star rises in your hearts"* (2 Peter 1:19).

Before the Bible was completed, the gift of prophesying included the predictive element because the prophets were getting revelation from God and writing it down. But after the Bible was completed, prophesying became the ability to speak forth the Word of God.

When Christians stand and, in truth, expose God's Word, we are functioning today in the sense of the prophet. We are shining forth the Word of God so that everyone can understand it.

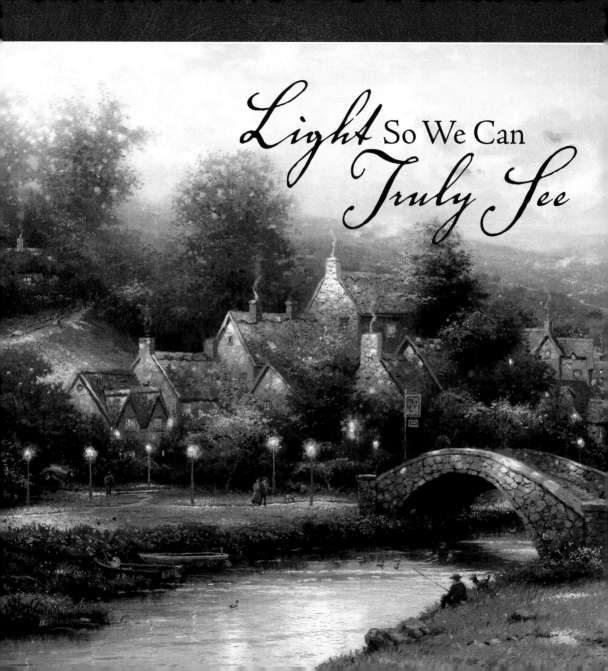

Light So We Can *Truly See*

"No one, when he has lit a lamp, puts it in a secret place or under a basket, but on a lampstand, that those who come in may see the light. The lamp of the body is the eye. Therefore, *when your eye is good,* your whole body also is full of light. But when your eye is bad, your body also is full of darkness. Therefore take heed that the light which is in you is not darkness. If then your whole body is full of light, having no part dark, the whole body will be full of light, as when the bright shining of a lamp gives you light."

LUKE 11:33–36

Miracles were wrought many times throughout Scripture—such as during the ministries of Elijah and Elisha, during the leadership of Moses, during the life of Jesus, and as the apostles carried on the ministry of Christ. But only Jesus ever healed the blind.

Others came close, like Ananias with Paul in the New Testament, but there is never any indication in any of the miracle pages of the Bible where anyone but Jesus ever healed a blind person. And Jesus did it nine recorded times.

This seems to indicate there is a certain kind of sickness that only Jesus Christ can cure. That sickness, represented in Scripture by physical blindness, is the spiritual blindness of a human heart.

Only Jesus Christ can heal and save your soul.

"Your eyes are windows into your body. If you open your eyes wide in wonder and belief, your body fills up with light. If you live squinty–eyed in greed and distrust, your body is a dank cellar. If you pull the blinds on your windows, what a dark life you will have!"

MATTHEW 6:22–23 MSG

The eye is a metaphor for vision. Jesus promises that with the eyes of faith we can discern light and darkness, good and evil. Like a trained artist, we can see what's really there. When we see the real world, Jesus says that our heart affects our eyes. Our desire determines our direction. He's calling us to see everything from a new perspective. He is saying the lens through which we look determines what we see and literally where we end up.

No one can serve two masters; for either he will hate the one and love the other, or else he will be loyal to the one and despise the other. You cannot serve God and mammon. MATTHEW 6:24

You can't be single–focused in two different ways. You can't serve God and something else, like mammon, which most people believe to be a synonym for money. You have to choose your focus.

LIGHT OF THE NEXT STEP

Years ago I was preaching in West Virginia, and one of the men in the church took several of us down into a mine. He said, "I am going to show you what it's really like to be surrounded by darkness." Now most of us think we've been in the dark, but my friend, you have never been in the dark until you've been in the bowels of the earth and they shut all the lights off. That is darkness! We were wearing those mining hats 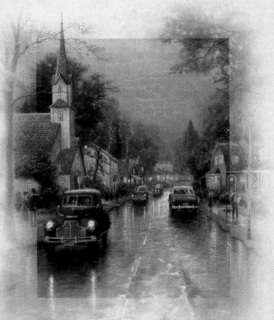 with little lamps on them, and after we had the darkness experience, we turned those lamps on to walk through the dark tunnels. I didn't know where we were going, and I couldn't see very far.

After that experience, I was struck with how it's like our walk with God. You see, in the darkness of the tunnel with our helmet lamps as our only light, we could stand at the mouth of the tunnel and say, "I am not taking one step until I can see all the way to the end."

With that stubborn attitude, we would never have moved because no lamp is powerful enough to eliminate all darkness.

But if we take a step into the light that we have, then the light shines one step further into the darkness. So it is in our Christian walk. We *walk in the light as He is in the light* (1 John 1:7), and each step brings more light for the next step of our journey.

Christian, God may be wanting to show you so much of His Word that He cannot show you because you are unwilling to walk into the light He's already given you. And you stand there with all of the possibilities of wisdom surrounding you, and yet the darkness envelops you because you will not be obedient.

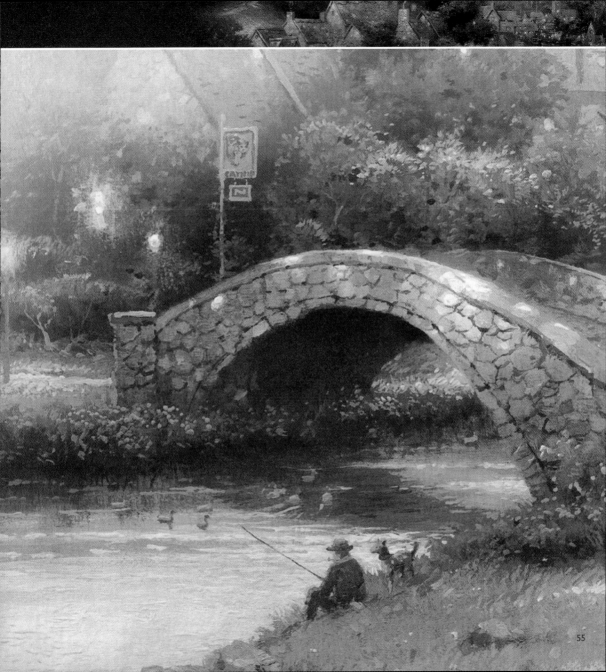

In Him was life, and the
life was the light of men.
And the light shines in the
darkness, and the darkness
did not comprehend it.

JOHN 1:4–5

Choosing
Darkness
rather
than *Light*

"No one, when he has lit a lamp, puts it in a secret place or under a basket, but on a lamp-stand, that those who come in may see the light. The lamp of the body is the eye. Therefore, when your eye is good, your whole body also is full of light.

But when your eye is bad, your body also is full of darkness. Therefore take heed that the light which is in you is not darkness. If then your whole body is full of light, having no part dark, the whole body will be full of light, as when the bright shining of a lamp gives you light."

LUKE 11:33–36

Anyone without the light of the world is walking out into the blackness and darkness of life.

Judas left Jesus at night. That is more than just a time of day; it symbolically describes the fact that when you walk away from the loving compassion of the Lord Jesus, you always walk out into the night. And Judas, when he finally turned his back upon the love of his Savior, went out into the night.

What does this mean to us in the here and now? Why study something so awful, and what can we learn from this passage on the betrayal of the Lord Jesus?

First, it reminds us of the reality of Satan's work among God's people. We dare not be surprised when we look around within the Body and discover division and ungodly carnal behavior. Satan loves to infiltrate the work of God, to sow seeds of dissension, and

to do everything he can to disrupt God's work.

Second, Judas teaches us the probability of hypocrites within the church. Judas was a hypocrite of the first magnitude. He was a deceiver. He knew what he was doing. He was not a Christian, but he hung out with Christians, and he played such a good game that everybody thought he was one of them.

Third, we see that it's possible to be close to Christ for an extended period of time and still be lost. Judas spent three years in intimate relationship with the Son of God. He walked with Him. He talked with Him. He prayed with Him. He listened to His sermons. He helped Him with His work. He was so trusted by the disciples that they appointed him the treasurer of the group. But he was lost. He was not a Christian. All of the outward expressions of Judas would have led you to believe, before his betraying act, that he was a believer.

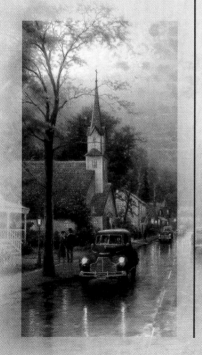

Having received the piece of bread, [Judas] then went out immediately. And it was night.

JOHN 13:30

It is possible for us to be involved in the church, to do all of the outward things that make people accept that we are children of light, when in reality we are still in darkness. Judas offers a sober warning to every one of us to examine our hearts to see whether or not we are truly in the light.

Jesus came into the world not simply to reflect who God is (John 1:1), not simply to create the things that are around us (John 1:3), but He came to minister to you and to me. He came to bring life, and His life is the light of all men.

But not everybody will accept Him.

He was in the world, and the world was made through Him, and the world did not know Him. He came to His own, and His own did not receive Him. JOHN 1:10, 11

That's an overwhelming thought. Here is the One in

whom is life and light and truth and love, and He came into a dark world that wouldn't comprehend Him. He tried to shine into the darkness and bring life where there was deadness, but He was rejected. So why do people reject Him? *"Because their deeds [are] evil."* That's the reason.

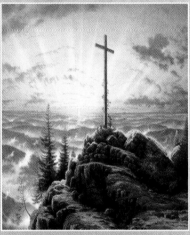

> *"And this is the condemnation, that the light has come into the world, and men loved darkness rather than light, because their deeds were evil. For everyone practicing evil hates the light and does not come to the light, lest his deeds should be exposed. But he who does the truth comes to the light, that his deeds may be clearly seen, that they have been done in God."*
>
> JOHN 3:19–21

You might say, "I don't accept Jesus Christ because I don't understand." No, that's not the reason. You don't accept Jesus Christ because you know if you accepted Him, you'd have to change the way you live. You don't want Jesus Christ coming into your life—you don't want His life and His light—because when the light shines, it exposes what's in the darkness. And exposure demands change.

The fundamental reason why men and women reject Jesus Christ as life and light in their lives is because they don't want to change. They love darkness rather than light.

But here is the good news! The light continues to shine! Whether we accept Him or not, Jesus still offers light to the world. He will shine into the darkness of hearts that will receive Him.

Thomas Kinkade

We Must Invite the Light to Enter

"No one, when he has lit a lamp, puts it in a secret place or under a basket, but on a lamp-stand, that those who come in may see the light. The lamp of the body is the eye. Therefore, when your eye is good, your whole body also is full of light. But when your eye is bad, your body also is full of darkness.

Therefore **take heed** *that the light which is in you is not darkness. If then your whole body is full of light, having no part dark, the whole body will be full of light, as when the bright shining of a lamp gives you light."*

LUKE 11:33–36

In Saint Paul's Cathedral in London, there is a picture by Holman Hunt called "The Light of the World." Maybe you have seen that picture and wondered as I have, why that title was given to this picture. At first glance it just doesn't seem to fit, but the title illustrates the spiritual genius of the artist. It is a picture of a cottage, rundown and neglected. Thistles have grown up to the height of the window. Grass has grown in the pathway. Vines and weeds are everywhere and the hinges on the door are rusty. But in the midst of this dishevelment and neglect is the kindliest form that you could ever imagine—the Lord in His regal robes. He has in one hand a lantern from which the light falls upon every crevice, and with His other hand, He is knocking at the door. Jesus is standing there, knocking at the door, and the glory of His light and blessedness falls upon the neglected cottage.

A familiar story about the painting has to do with a man who looked at the picture, and then went to see Mr. Hunt. The man said, "I know you are the artist, and you created this beautiful painting, but," he said, "you made a terrible mistake."

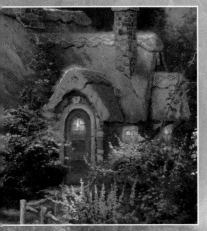

Mr. Hunt asked, "What do you mean?"

"I noticed there is no handle on the door."

The artist replied, "No, it is not a mistake. You misunderstand. The handle is on the inside. We must open the door."

When we open the door of our hearts, the glory of the Light falls upon our souls.

Martin Luther once wrote, "Before my conversion, had you knocked at the door of my heart and asked who lives there, I would have said, 'Martin Luther lives here.' Had you come in to see me, you would have found a monk with his head shaved, sleeping in a hair shirt, under his head two tables of stone, a scourge hanging down by the side of the bed. But now if you knock at the door of my heart and ask who lives here, I will reply, 'Martin Luther no longer lives here. Jesus the Lord lives here now.'"

There is light for darkness, and there is gladness for mourning, and there is joy for sorrow, and there is hope for despair when Jesus comes in. But Jesus will only come in if He is asked.

REFLECTING THE LIGHT

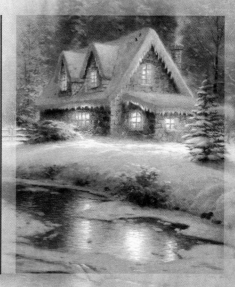

"There was a man sent from God, whose name was John. This man came for a witness, to bear witness of the Light, that all through him might believe. He was not that Light, but was sent to bear witness of that Light. That was the true Light which gives light to every man coming into the world."

JOHN 1:6–9

When God wanted to turn the light on, He sent John the Baptist to be a reflector. John wasn't the true light—he was just a reflector of the light—and he went everywhere preaching one message: *"Behold! The Lamb of God who takes away the sin of the world!"* (John 1:29). That's all he knew. He was trying to reflect the light so people could see who Jesus was. John the Baptist was the revealer of light.

"You have sent to John, and he has borne witness to the truth. Yet I do not receive testimony from man, but I say these things that you may be saved. He was the burning and shining lamp, and you were willing for a time to rejoice in his light." JOHN 5:33–35

It's easy to see a reflector and mistake it for the light. The moon has no glow of its own, just a reflection of the distant sun, but "moonlight" reigns over many romantic notions. Jesus had to remind the people that He was the light while John was the reflector; He was the sun, while John was merely a moon.

The Scripture says that for a time John was a *"burning and a shining light"* (John 5:35). The word "light" there is not the normal word for light; it's the word that means "a reflector," or "a wick," or "a light that does not have its own source." John was not a light that had his own source. John was simply a light that was reflecting Jesus Christ.

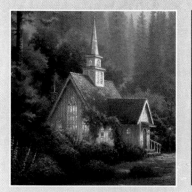

It's been said that a wick is not noticed until it fails to function properly. Its service is hidden. It is the light which catches the eye. The wick exists only to be consumed. If the wick survives, it has failed its purpose. John the Baptist was just a wick. He said, "I'm not the light. I'm just a wick." He was a burning and a shining wick for Jesus Christ.

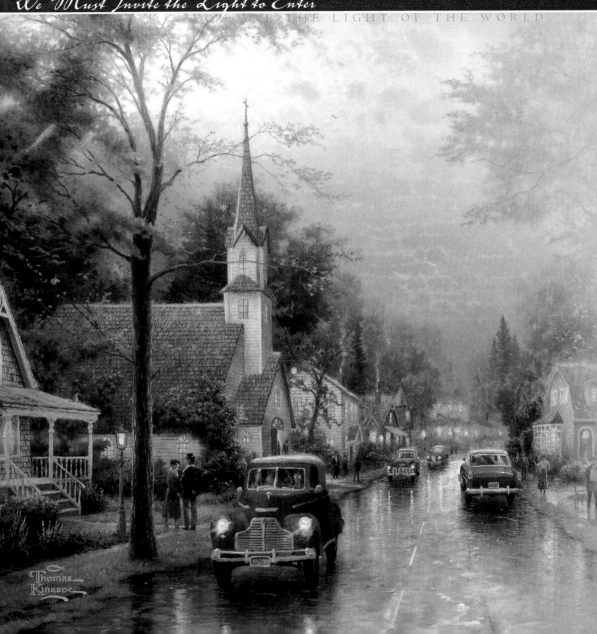

Thomas
Kinkade

THE LIGHT IN THE CENTER

In the apostle John's vision, he sees seven golden lampstands that are declared to be the seven churches. Lampstands, of course, represent light, and they are useful for the night. While the day lasts, they are needless. Jesus said, *"I must work the works of Him that sent Me while it is day; the night comes when no man can work"* (John 9:4). Now that Jesus Christ has left the world, the night will continue until He comes back, and then we will have day again. But to get us through the night, Jesus has lifted up the lampstands—the churches—to bring light to this world. The seven lampstands in the vision represent the corporate church; they represent all of us.

The lampstands that represented the churches were arranged in a circle, and in the center of this circle stood the Son of God. That is a true picture of the Lord Jesus Christ and the desired relationship He would have with us. He wants to be right in the center. Matthew 18:20 says, *"For where two or three are gathered together in My name, I am there in the midst of them."* Jesus wants to be the central figure in the church and in our lives.

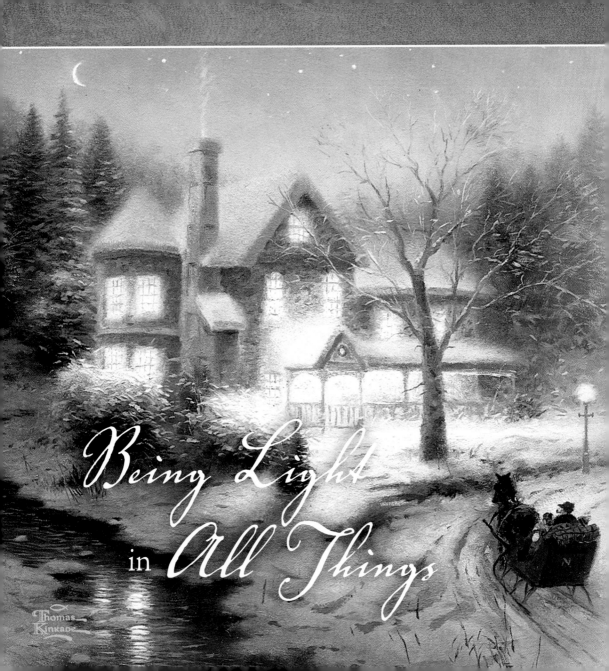

Being Light in All Things

Thomas Kinkade

"No one, when he has lit a lamp, puts it in a secret place or under a basket, but on a lampstand, that those who come in may see the light. The lamp of the body is the eye. Therefore, when your eye is good, your whole body also is full of light. But when your eye is bad, your body also is full of darkness. Therefore take heed that the light which is in you is not darkness. If then your whole body is full of light, having no part dark,

the whole body will be full of light,

as when the bright shining of a lamp gives you light."

LUKE 11:33–36

*A*ll who desire to live godly in Christ Jesus will suffer persecution. But evil men and impostors will grow worse and worse, deceiving and being deceived. But you must continue in the things which you have learned and been assured of, knowing from whom you have learned them, and that from childhood you have known the Holy Scriptures, which are able to make you wise for salvation through faith which is in Christ Jesus. All Scripture is given by inspiration of God, and is profitable for doctrine, for reproof, for correction, for instruction in righteousness, that the man of God may be complete, thoroughly equipped for every good work. 2 TIMOTHY 3:12–17

When we think of light, we think of energy. And "energy" is "the ability to do work."

Good works determine our effectiveness. When we have the Word of God in our life, it makes us proficient, it completes us, it equips us for future service, and it makes us productive.

Jesus put it this way, "*Let your light so shine before men that they may see your good works and glorify your Father in heaven*" (Matthew 5:16). When people see what we do because we are Christians, because we are productive, because we've been in the Word of God and been nourished by the Word of God, and are producing good works, they ought to be saying, "You know what? That's another one of those Christians. That's one of them."

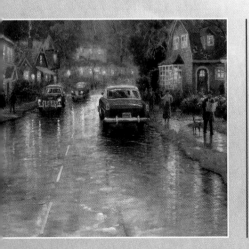

That's a great thought—being "one of them!" Live so that others glorify your Father in heaven because they see the good works you do.

It's good works. It's the life we live. Friend, if you are walking around spouting Jesus stuff, and your life is all messed up, please keep quiet until you bring your life into phase with your message because the Word without reality does more damage than good. That doesn't mean you have to be perfect. None of us is. If we had to be per-

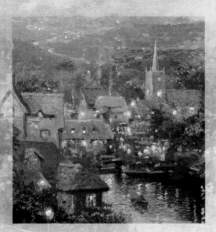

fect before we could talk about Christ, we'd all be quiet. But if your lifestyle dishonors the Lord, don't be running around giving testimonies. Let your life be clean and right, then your life can bring honor and glory to the Lord.

My father started preaching the Bible in 1935, and he kept preaching until the day before he died in 2000. In going through his old Bibles, I've been reading all the notes written in the margins, and I've discovered that my dad was writing notes in his Bibles that look like the notes I write in my Bibles. It's the same response to God's Word. My dad was preaching messages in 1935 just like the messages I preach today. Different cultural responses, but the same book. Throughout sixty–five years of ministry, he was studying this book and teaching this book and trying the best he knew how to live this book. Dad wasn't a perfect man by any means, but the Word of God made him what he was, caused all of his children to be Christians, and raised up a small college where they're teaching the Word of God. It's the Word of God! Friend, this is the faith of our fathers. This is our spiritual heritage.

It's time to dust off our Bibles. Let's put God's Word to work so we can work for Him.

THE LIGHT OF FAITHFULNESS

[Stephen], being full of the Holy Spirit, gazed into heaven and saw the glory of God, and

Jesus standing at the right hand of God, and said, "Look! I see the heavens opened and the

Son of Man standing at the right hand of God!" ACTS 7:55-56

Do you know what the Spirit of God does? He makes you what you could not naturally be without Him.

For instance, nobody has the human power to respond to judgment and criticism and the throwing of stones as Stephen the martyr did, but God's Spirit within him made the difference (Acts 7:55).

People like Stephen aren't just characters in some story; they're not even mere historical figures. They are testimonies that God put in the Bible in order for us to know more about His people and His will. They're in the Word as examples to pull the expectation level higher, to inspire us to say, "Lord God, how can I be a man of courage and conviction like that?" But this only happens when we rely upon God and when we let the Spirit of God control our lives consistently. Then we can live like Stephen. When the pressure comes into our lives, our faces might not shine like an angel, but we will be different because Jesus

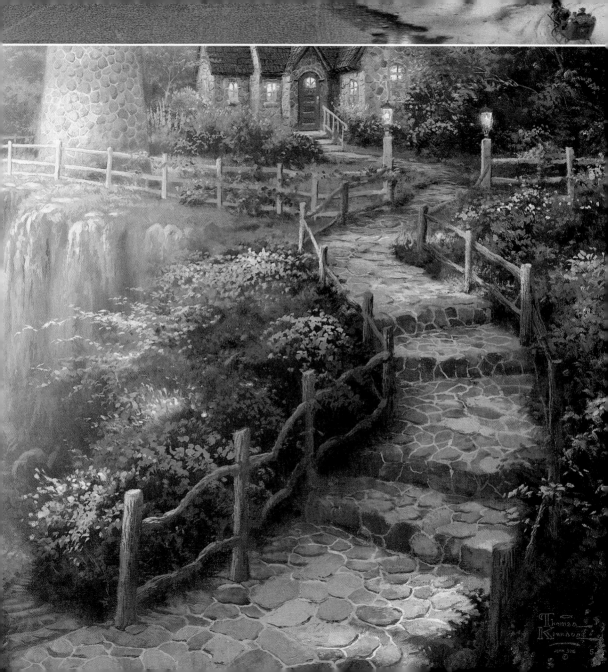

Christ is living within us. When the pressure comes, we reveal what God is doing in our lives because we walk with God.

The tragedy of Stephen's life is that he died young. Some people have speculated that had he been around to live out his life, he might have been more powerful than the Apostle Paul himself. But in the time that he had, Stephen made a difference.

THE LIGHT IN SUFFERING

Suffering is the precursor to glory. In this realm of life, there will be some suffering, but the suffering is not to be compared with the glory that will be ours one day.

> *I consider that the sufferings of this present time are not worthy to be compared with the glory which shall be revealed in us. For the earnest expectation of the creation eagerly waits for the revealing of the sons of God. For the creation was subjected to futility, not willingly, but because of Him who subjected it in hope; because the creation itself also will be delivered from the bondage of corruption into the glorious liberty of the children of God. For we know that the whole creation groans and labors with birth pangs together until now. Not only that, but we also who have the firstfruits of the Spirit, even we ourselves groan within ourselves, eagerly waiting for the adoption, the redemption of our body. For we were saved in*

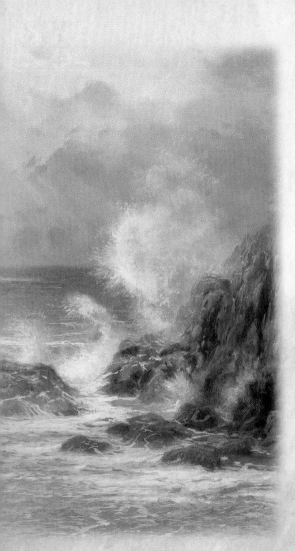

this hope, but hope that is seen is not hope; for why does one still hope for what he sees? But if we hope for what we do not see, we eagerly wait for it with perseverance. Likewise the Spirit also helps in our weaknesses. For we do not know what we should pray for as we ought, but the Spirit Himself makes intercession for us with groanings which cannot be uttered. Now He who searches the hearts knows what the mind of the Spirit is, because He makes intercession for the saints according to the will of God. And we know that all things work together for good to those who love God, to those who are the called according to His purpose. ROMANS 8:18–28

Consider Stephen.

Opponents of Christianity *"stirred up the people, the elders, and the scribes; and they came upon him, seized him, and brought him to the council. They also set up false witnesses . . . and all who sat in the council, looking steadfastly at him, saw his face as the face of an angel"* (Acts 6:12–15).

Now let's just suppose this was happening to you. Would witnesses say, "That was the face of

an angel!"? Or would you have a face filled with resentment and fear? Many people say, "I have the joy of Jesus in my heart." But somehow that joy does not show up in their countenance.

Stephen had the face of an angel! It wasn't his spiritual arguments that ultimately won the cause; it was his face.

We can never quite understand the sovereign purposes of God, but Stephen, because of his godly purpose and passion, accomplished more in his few years than most people do in a whole lifetime. He walked with God in such a way that just as Moses came from the mountain with the face of glory, Stephen, in the midst of pressure, had that same glow . . . that same glory.

Oh, that we could have just a little bit of that in our lives! Wouldn't it be wonderful if people would come up to you on the street and say, "I noticed your face. What is it about you?" And you'd be able to say, "What's going on with my face is that Jesus lives in my heart. He has forgiven my sin, filled me with His Spirit, and how can I be anything but joyous?"

Your face is a testimony. Ask God to help you express the wonderful joy and purpose of Jesus in your face.

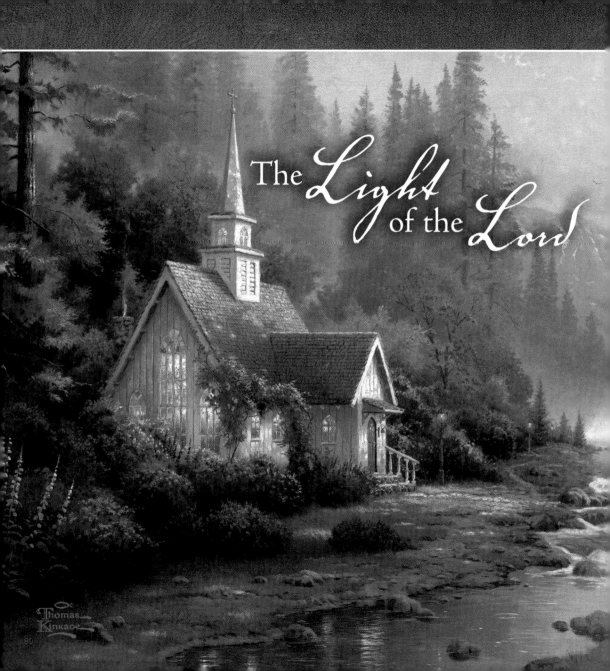

The *Light* of the *Lord*

"No one, when he has lit a lamp, puts it in a secret place or under a basket, but on a lampstand, that those who come in may see the light. The lamp of the body is the eye. Therefore, when your eye is good, your whole body also is full of light. But when your eye is bad, your body also is full of darkness. Therefore take heed that the light which is in you is not darkness. If then your whole body is full of light, having no part dark, the whole body will be full of light, as when *the bright shining of a lamp* gives you light."

LUKE 11:33–36

The face of the Lord is the central feature of His person. It represents everything that He is. Everything fades in the light of its brilliance. The Bible is filled such descriptions.

And [Jesus] was transfigured before them. His face shone like the sun, and His clothes became as white as the light. MATTHEW 17:2

"At midday, O king, along the road I saw a light from heaven, brighter than the sun, shining around me and those who journeyed with me." ACTS 26:13

And then the lawless one will be revealed, whom the Lord will consume with the breath of His mouth and destroy with the brightness of His coming. 2 THESSALONIANS 2:8

And so we have the prophetic word confirmed, which you do well to heed as a light that shines in a dark place, until the day dawns and the morning star rises in your hearts.

2 PETER 1:19

And His countenance was like the sun shining in its strength.

REVELATION 1:16

"I, Jesus, have sent My angel to testify to you these things in the churches. I am the Root and the Offspring of David, the Bright and Morning Star." REVELATION 22:16

Behold, He is coming with clouds, and every eye will see Him, even they who pierced Him. And all the tribes of the earth will mourn because of Him. Even so, Amen. I am the Alpha and the Omega, the Beginning and the End," says the Lord, *"who is and who was and who is to come, the Almighty."*

REVELATION 1:7- 8

According to the book of Revelation, by the time Jesus returns, all the stars will be gone, the sun and the moon will be gone, and it will be totally black, totally dark. But then a Light

brighter than the sun will appear in the darkness of the world, and it will be seen by every eye!

Listen carefully. Here is the Son of Man clothed with power and majesty, with awe and terror. That long royal robe; that golden belt buckled at the breast; that hair so glistening white that it hurts the eye; those eyes flashing of fire, eyes that read every heart and penetrate every hidden corner; those feet glowing in order to trample down the wicked; that loud reverberating voice, like the mighty breakers booming against the rocky shore; that sharp, long, heavy great–sword with two biting edges; yes, that entire appearance *"like the sun shining in its strength"* (Revelation 1:16), too intense for human eyes to stare at—the entire picture, taken as a whole, is symbolic of Christ, the Holy One, coming to purge His churches. It is an awesome picture!

That's who we have to face someday.

The Son of Man is the One every man and woman in the world will face one day.

"And lo, the angel of the Lord came upon them and the glory of the Lord shone round about them."
LUKE 2:9 KJV.

The glory of the Lord is a great study in the Bible. We find it in the Old Testament called the *Shechinah* glory. It was the glory that filled up the temple and the tabernacle to indicate the presence of God Almighty.

We read in the book of Ezekiel the people of Israel disobeyed God and they came to such a level of disobedience that God removed His glory from out of the temple and from out of the city and finally away from His people. The book of Ezekiel is a sad description of God's glory departing from His people.

And from the end of the book of Ezekiel and until you come to the New Testament, there is no recurrence of the glory of God. The *Shechinah* glory has departed from God's people, and there is nothing but darkness. That period of time—between the Old and the New Testament—is called the 400 silent years because there is no word from God. It is only darkness.

But the light reappeared that night in Bethlehem when God's glory came down in a baby . . . it was light in the midst of darkness.

Jesus is the glory of God, the Light of the World, and the hope of all people.

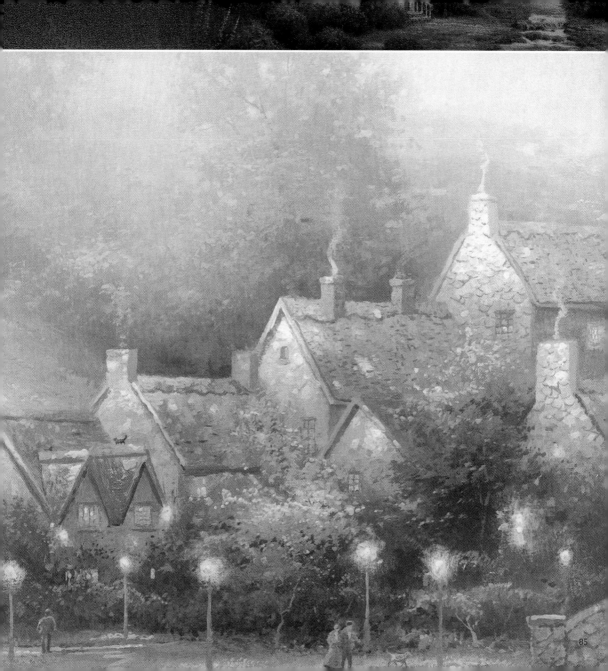

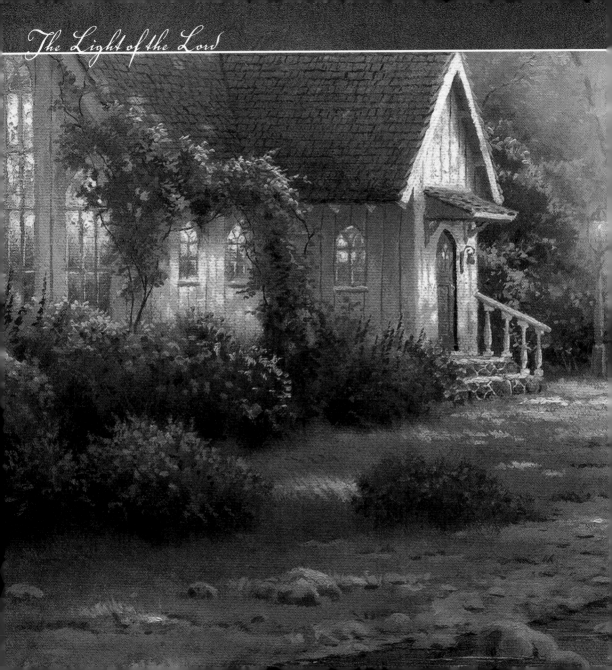

Arise, shine; For your light has come! And the glory of the Lord is risen upon you. For behold, the darkness shall cover the earth, And deep darkness the people; But the Lord will arise over you, And His glory will be seen upon you. The Gentiles shall come to your light, And kings to the brightness of your rising.

ISAIAH 60:1–3

THE SECRET OF THE LIGHT

The secret of the light is that there is no secret; the very nature of light is revelation.

God in His love has revealed everything we need to know in order to live forever in His Light, and God in His mercy has warned us to beware *"the day when God will judge the secrets of men"* (Romans 2:16). We cannot hide from what is to come. *"Nothing is secret that will not be revealed, nor anything hidden that will not be known and come to light"* (Luke 8:17).

All we can do is prepare. *"And do this, knowing the time, that now it is high time to awake out of sleep; for now our salvation is nearer than when we first believed. The night is far spent, the day is at hand. Therefore let us cast off the works of darkness, and let us put on the armor of light. Let us walk properly, as in the day, not in revelry and drunkenness, not in lewdness and lust, not in strife and envy"* (Romans 13:11–13).

It's time to shine!

You are a chosen generation, a royal priesthood, a holy nation, His own special people, that you may proclaim the praises of Him who called you out of darkness into His marvelous light; who once were not a people but are now the people of God, who had not obtained mercy but now have obtained mercy.

1 Peter 2:9–10

ABOUT THE AUTHORS

THOMAS KINKADE is an accomplished artist, aptly named the Painter of Light® for the golden tones that dance across his creations. His artistic excellence has earned him numerous awards, including the 1994 Artist of the Year from the National Association of Limited Edition Dealers, 1995 Collector Editions Award of Excellence, and 1995–1998 Graphic/Lithograph of the Year. A committed Christian, husband, and father, Mr. Kinkade lives in Northern California with his wife, Nanette, and four daughters.

FOR MORE INFORMATION about Mr. Kinkade, his works, and his ministries, visit www.thomaskinkade.com.

DAVID JEREMIAH is senior pastor of Shadow Mountain Community Church in El Cajon, California, and Chancellor of Christian Heritage College. His award-winning radio and television broadcast, "Turning Point," reaches thousands of people every day, both nationally and internationally. Dr. Jeremiah has authored numerous books, including *When Your World Falls Apart*, *Escape the Coming Night*, *The Handwriting on the Wall*, co-written with C.C. Carlson, *Slaying the Giants in Your Life*, and *Searching for Heaven on Earth*. Dr. Jeremiah is also a frequent speaker for professional basketball, baseball and football chapels. He and his wife, Donna, live in El Cajon, California.

FOR MORE INFORMATION about Dr. Jeremiah, his works, and his ministries, visit www.turningpointonline.org.

Featured Paintings

 Garden of Grace (1995)

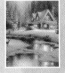 Deer Creek Cottage (1995)

 Sunrise (1999)

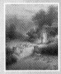 The Good Shepherd's Cottage (2001)

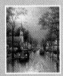 Hometown Morning (2000)

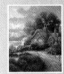 A New Day Dawning (1997)

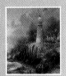 The Light of Peace (1996)

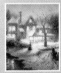 Moonlit Sleigh Ride (1992)

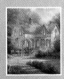 Home Is Where the Heart Is II (1996)

 The Forest Chapel (1999)

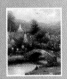 Lamplight Village (1995)

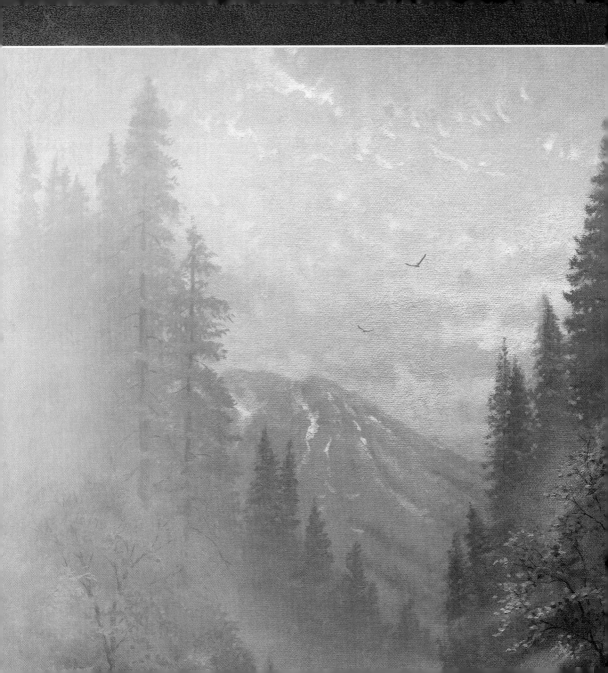

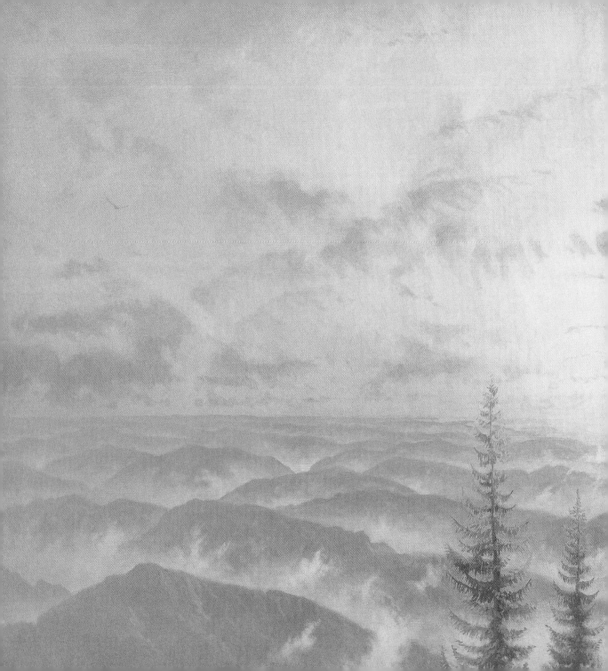